MANDATORY TITLE PAGE WITH THE TITLE (EVERYTHING IS OKAY SO FAR) AND MAYBE ALSO THE AUTHOR (EMILY PAN)

© 2012 Emily Pan. All rights reserved.
ISBN 978-1-105-46852-0

Hi.

I haven't read enough books to know what I should put on this first page, but I figured I couldn't go wrong with a friendly little greeting. So...

Hey there.

How are you?

To be honest, I thought it might be easier to make conversation with you if I had the advantage of time to think of nice words that I could plug into thesaurus.com mid-sentence. Talking to you this way also protects me from any chance of confrontation. It's a pretty good deal, but I'm finding myself having the trouble of not being able to segue into any sort of concrete point.

I guess that's okay though, because that's what a lot of my life is like.
Also, it looks like I've been able to fill my first page. Congratulations! I'm ecstatic.

If you're worried that this page is going to set the tone for the rest of the book, don't be. I'm fully aware of my conversational ineptitude and have filled the pages with pictures! Loads and loads of pictures. As this is only supposed to be a kind of collective diary for myself, the only words you'll find are snippets from my journal, neatly arranged in no particular order.

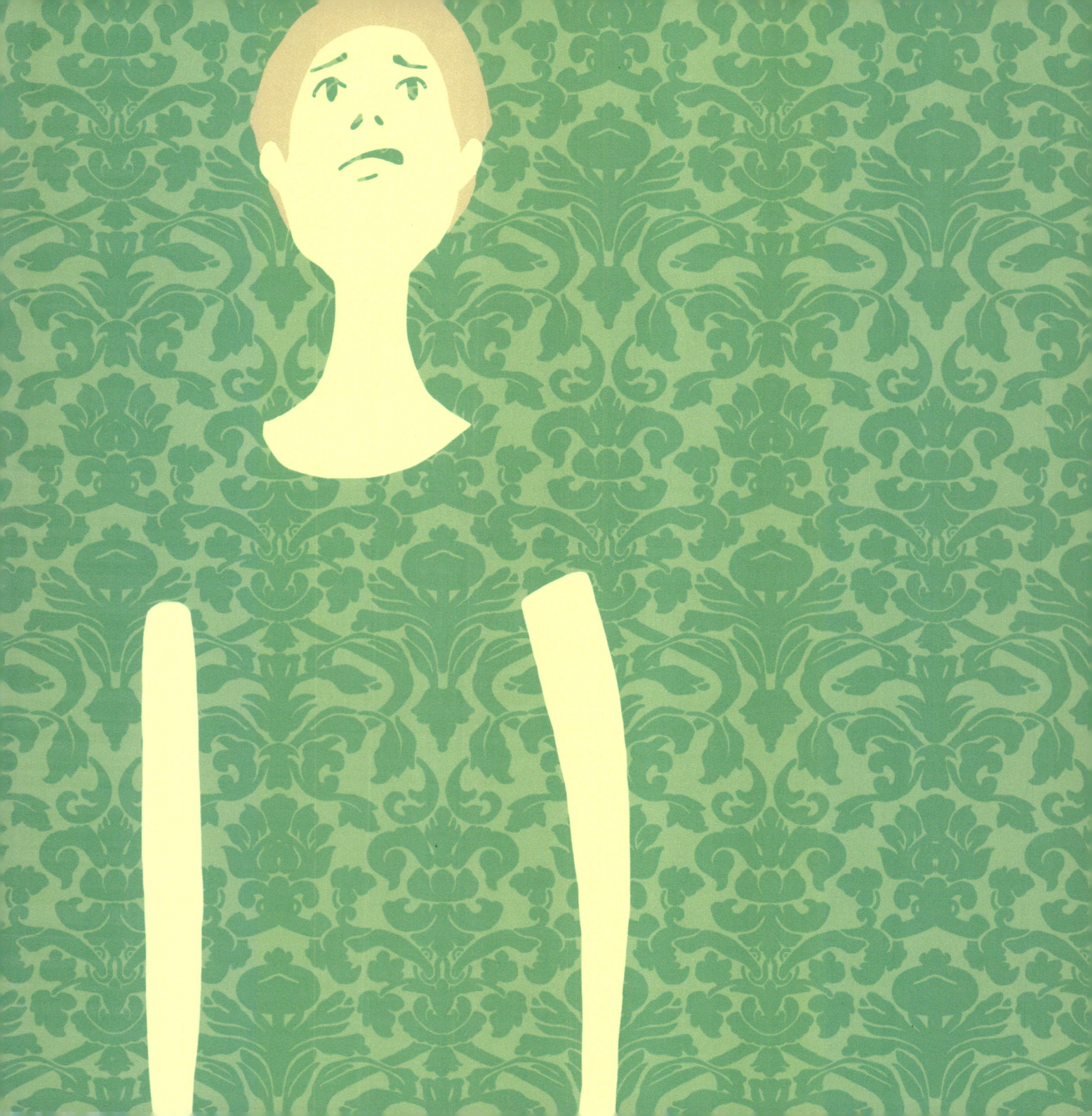

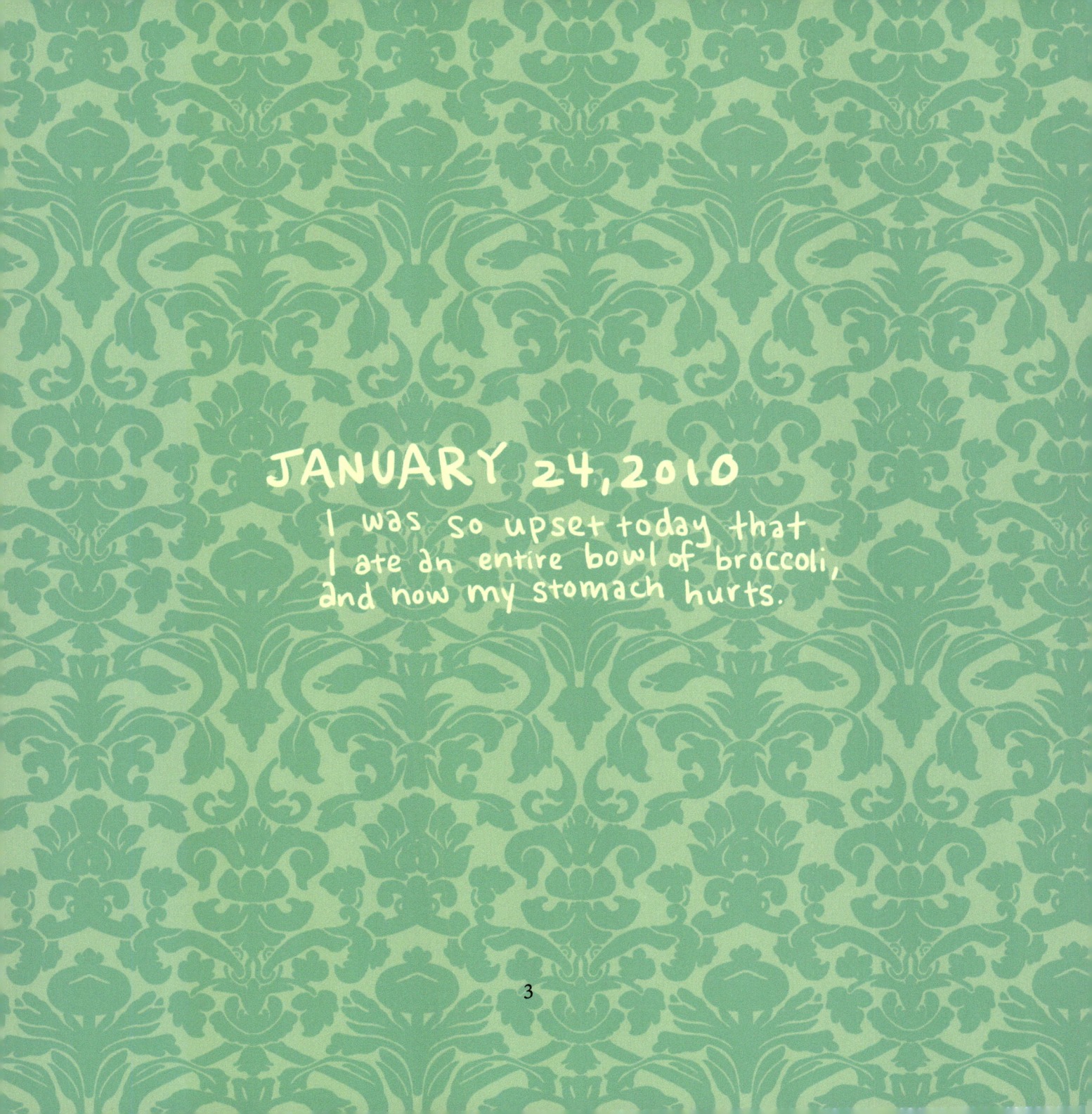

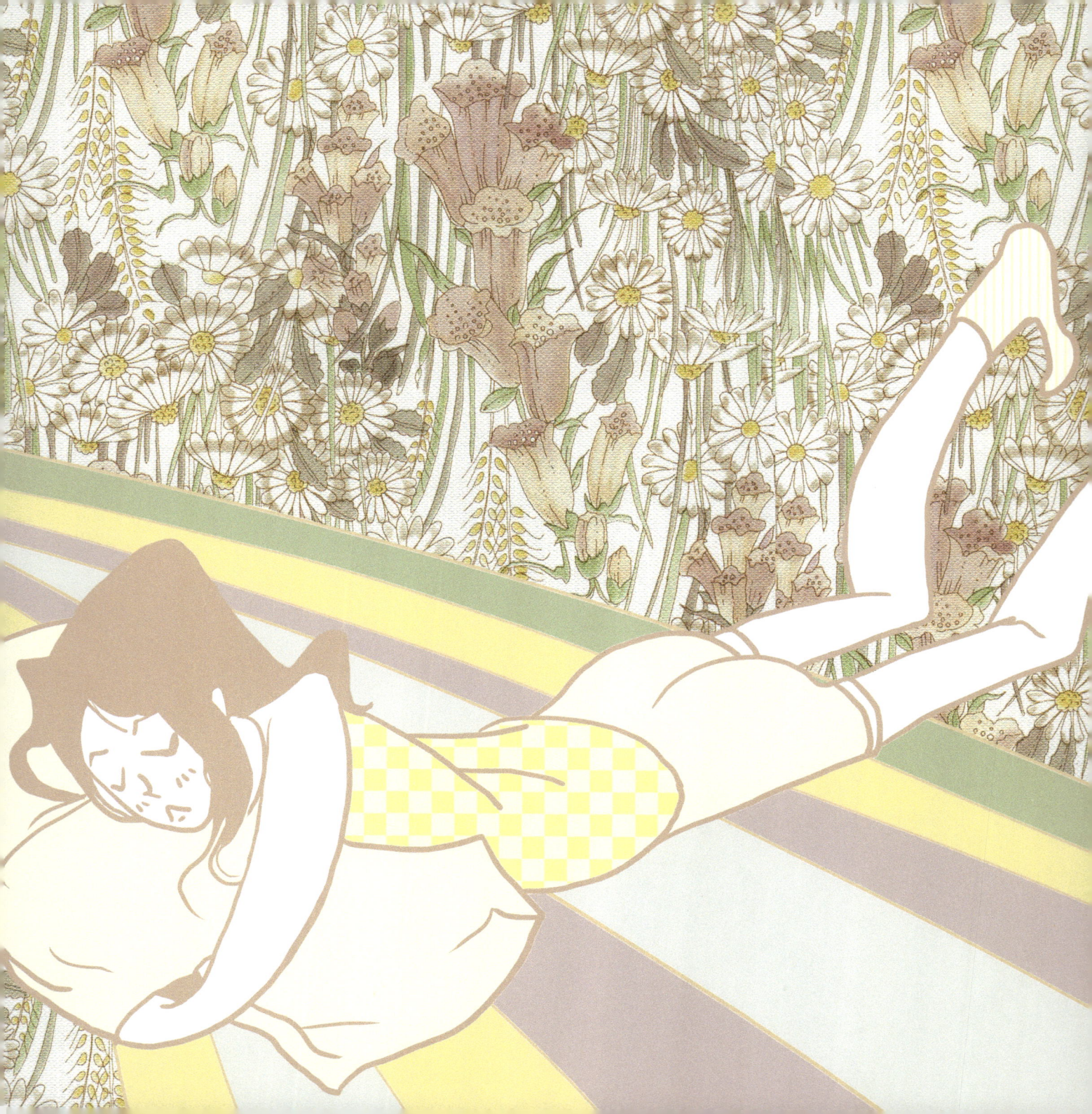

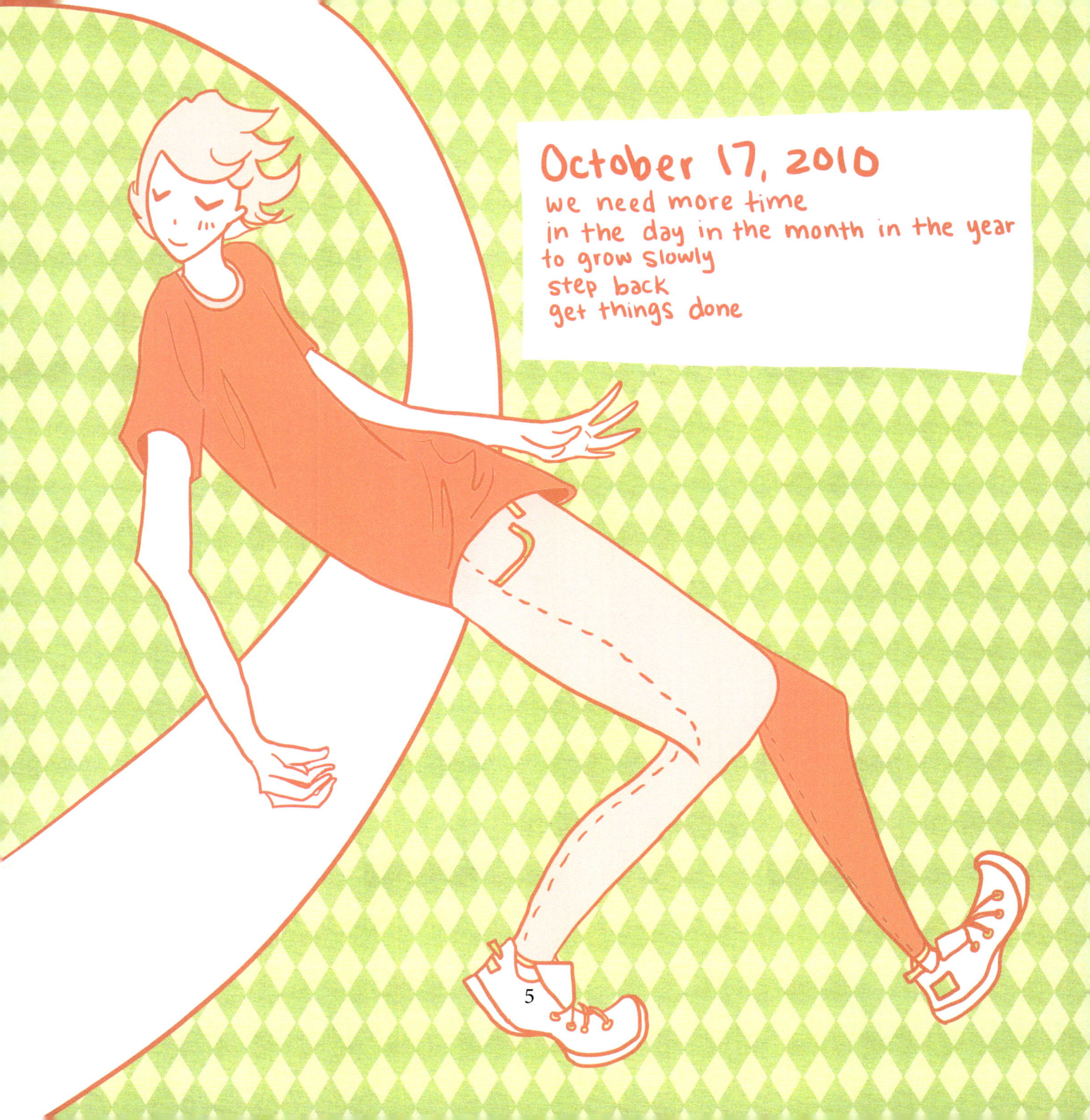

August 05, 2010
brain is apathetic
heart keeps going

kind of sentimental

it's a good day to sleep on
the living room floor.

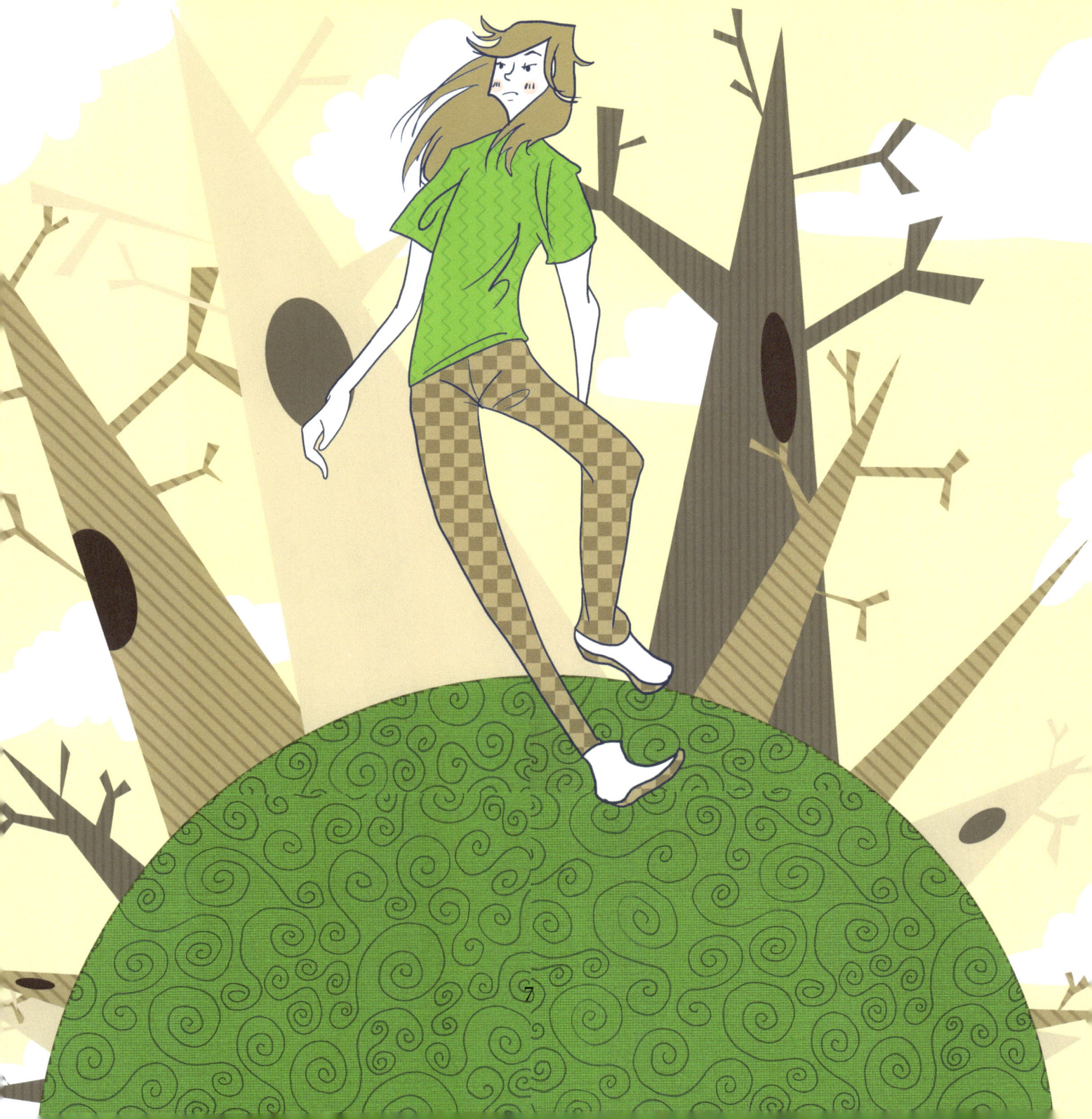

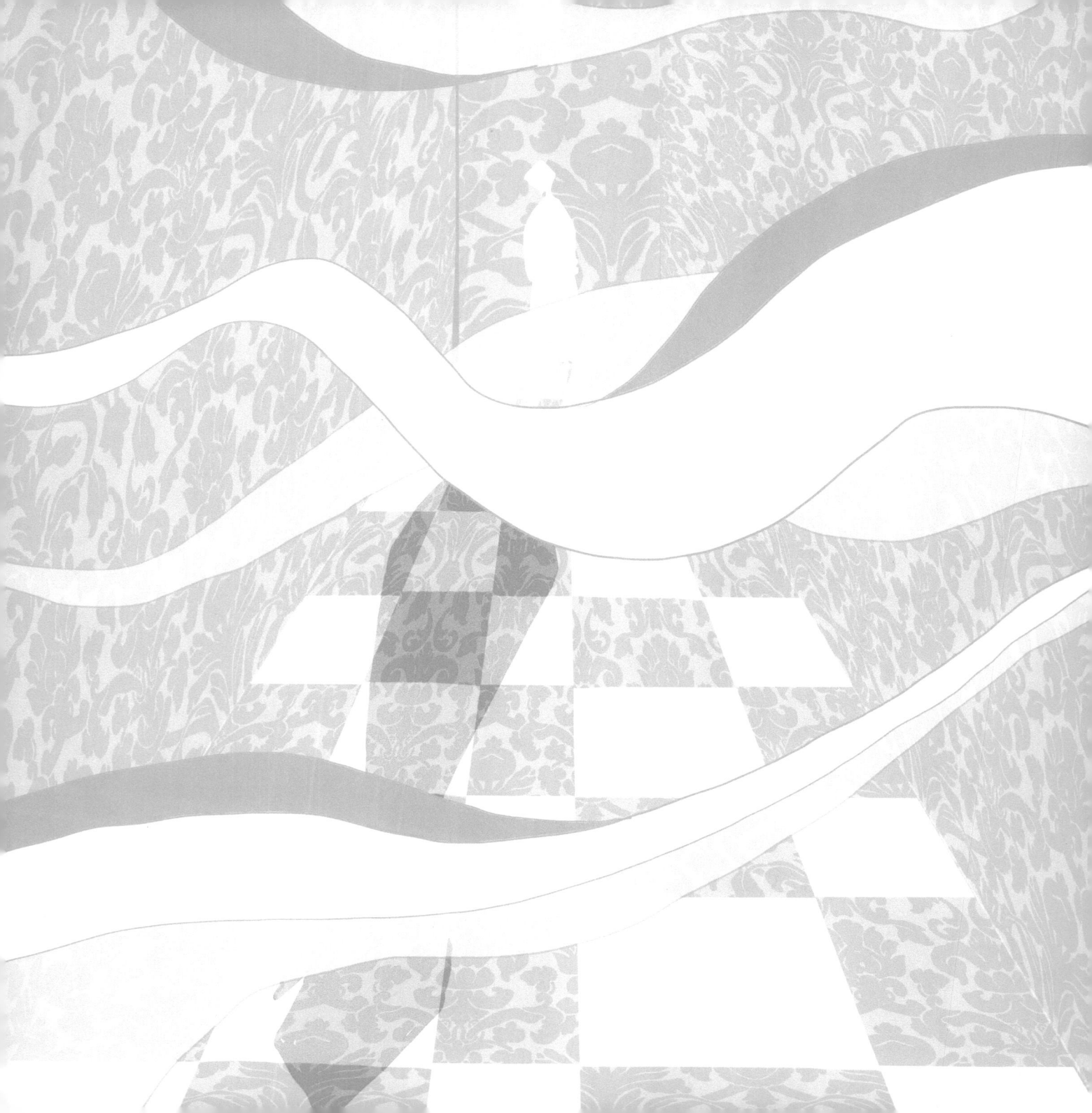

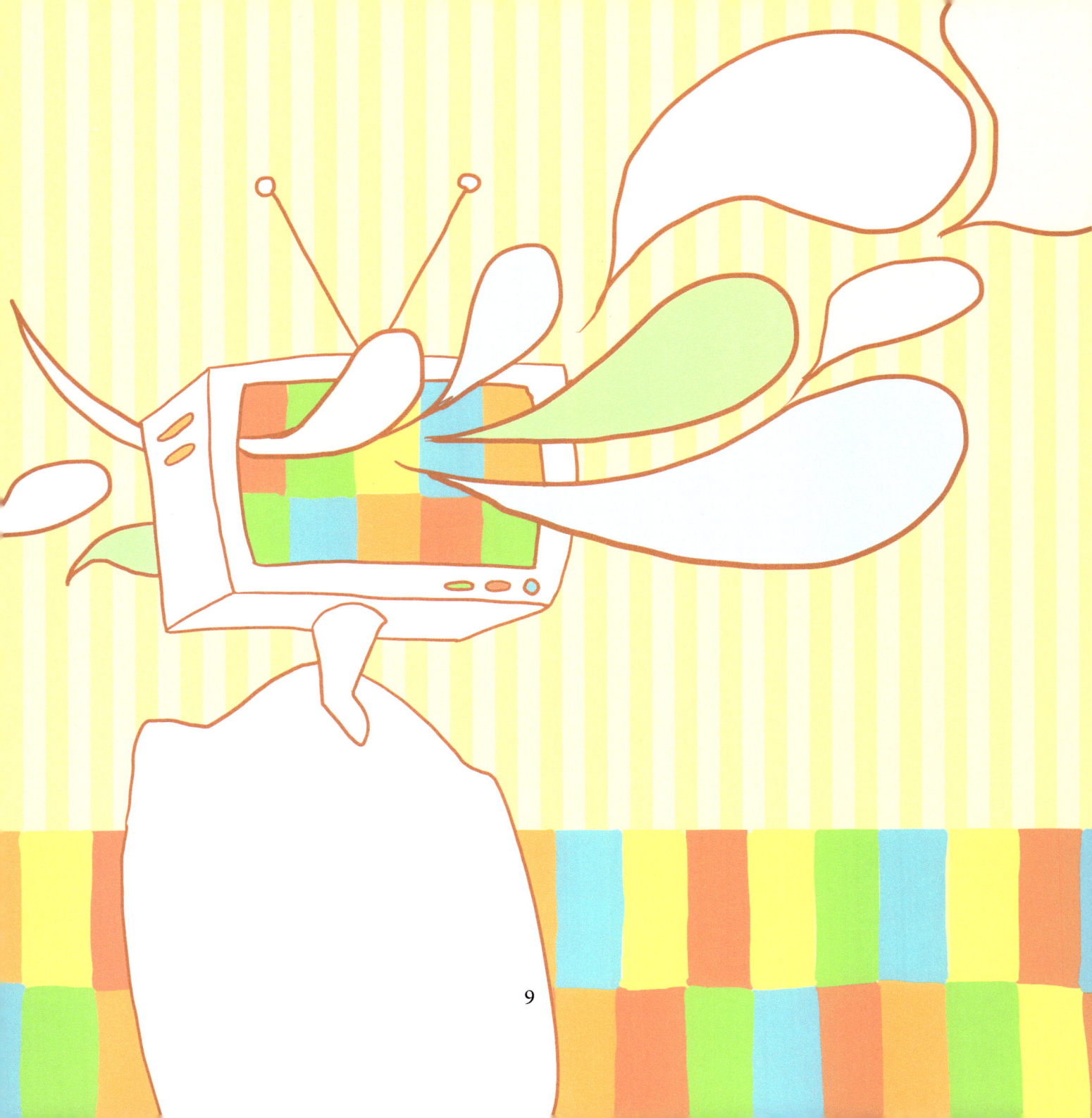

May 09, 2011

Everyone's excited about getting out in the world and I feel like I'm the only one left behind

always wishing

to stay in the past

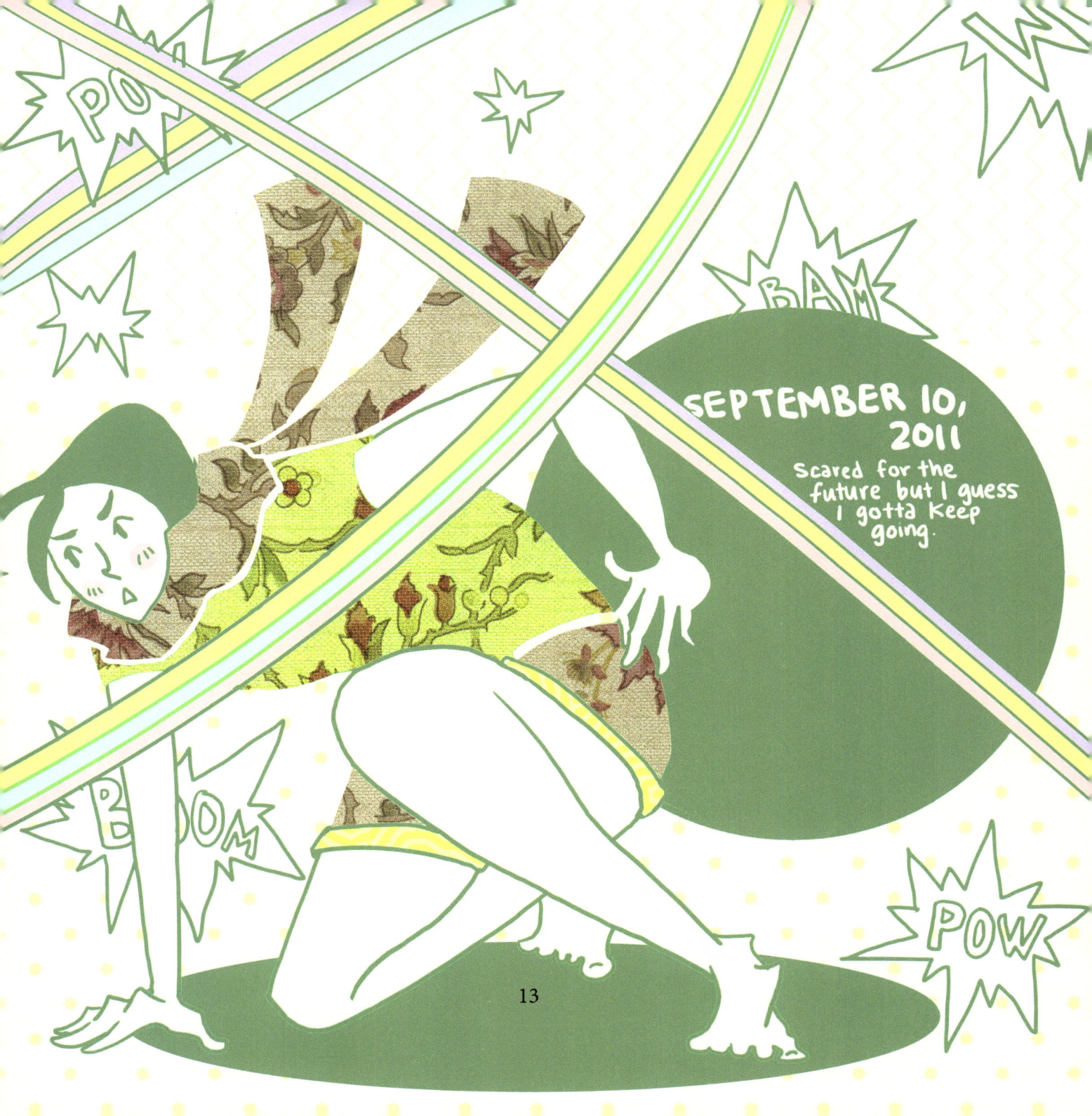

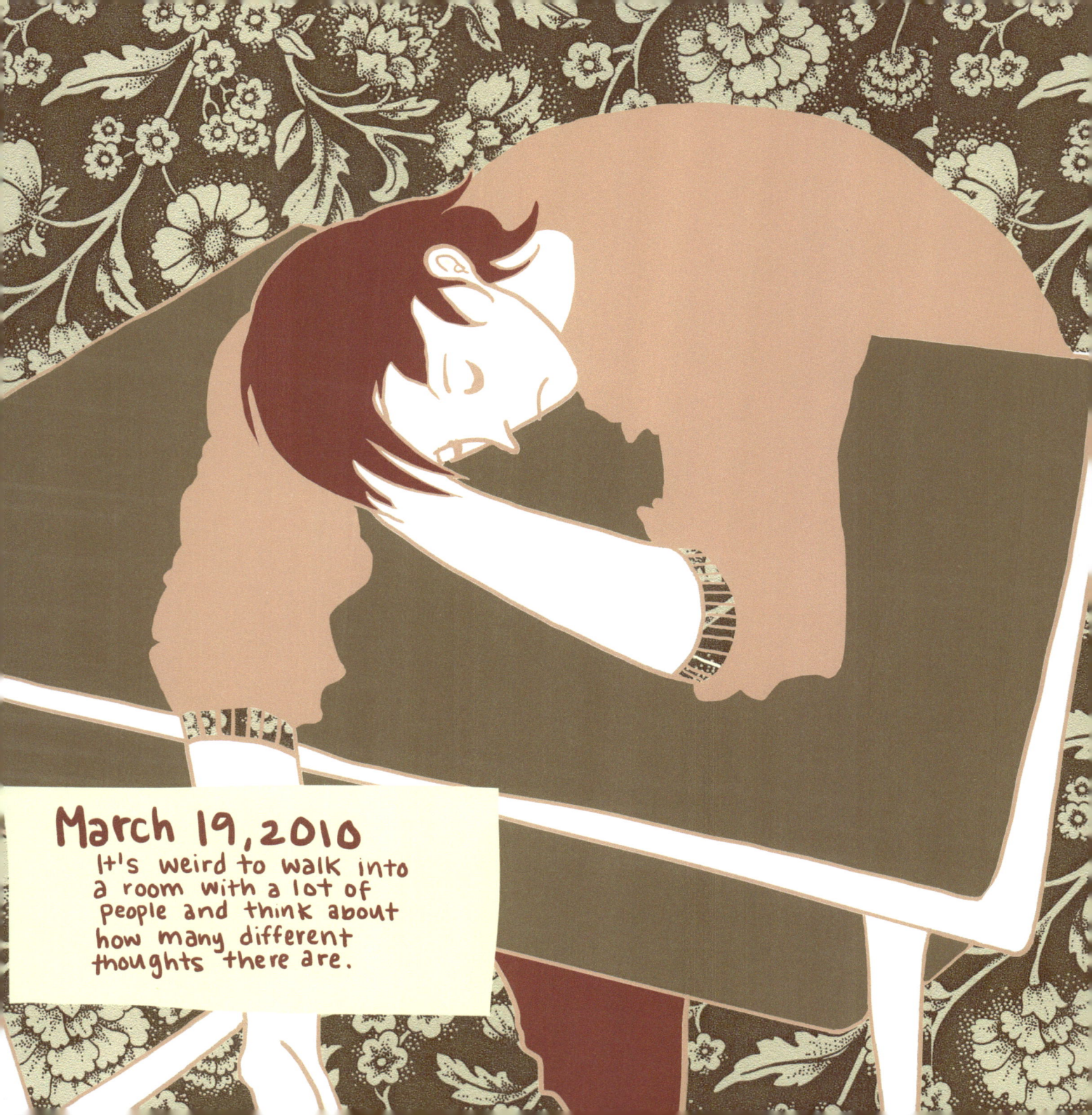

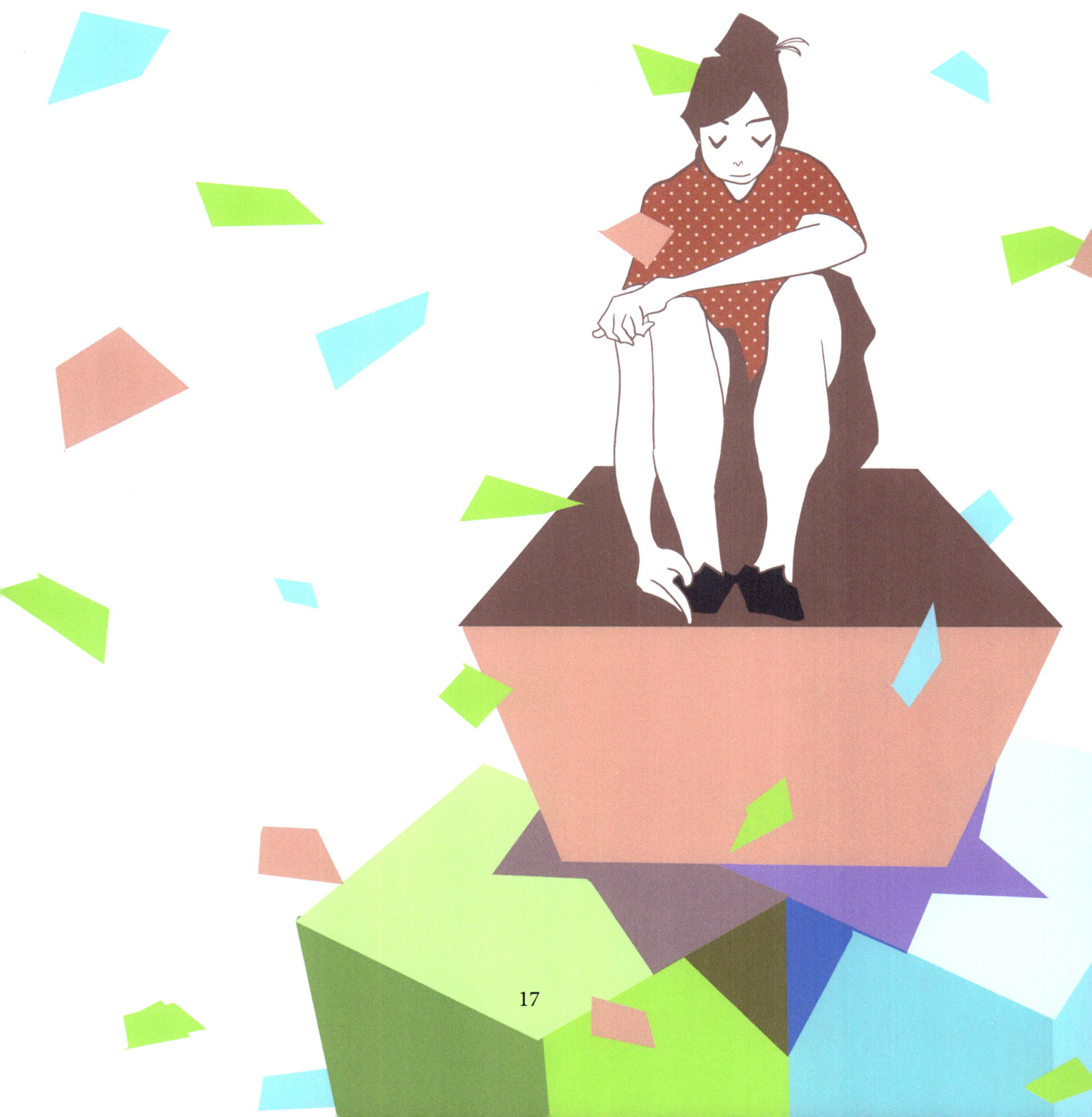

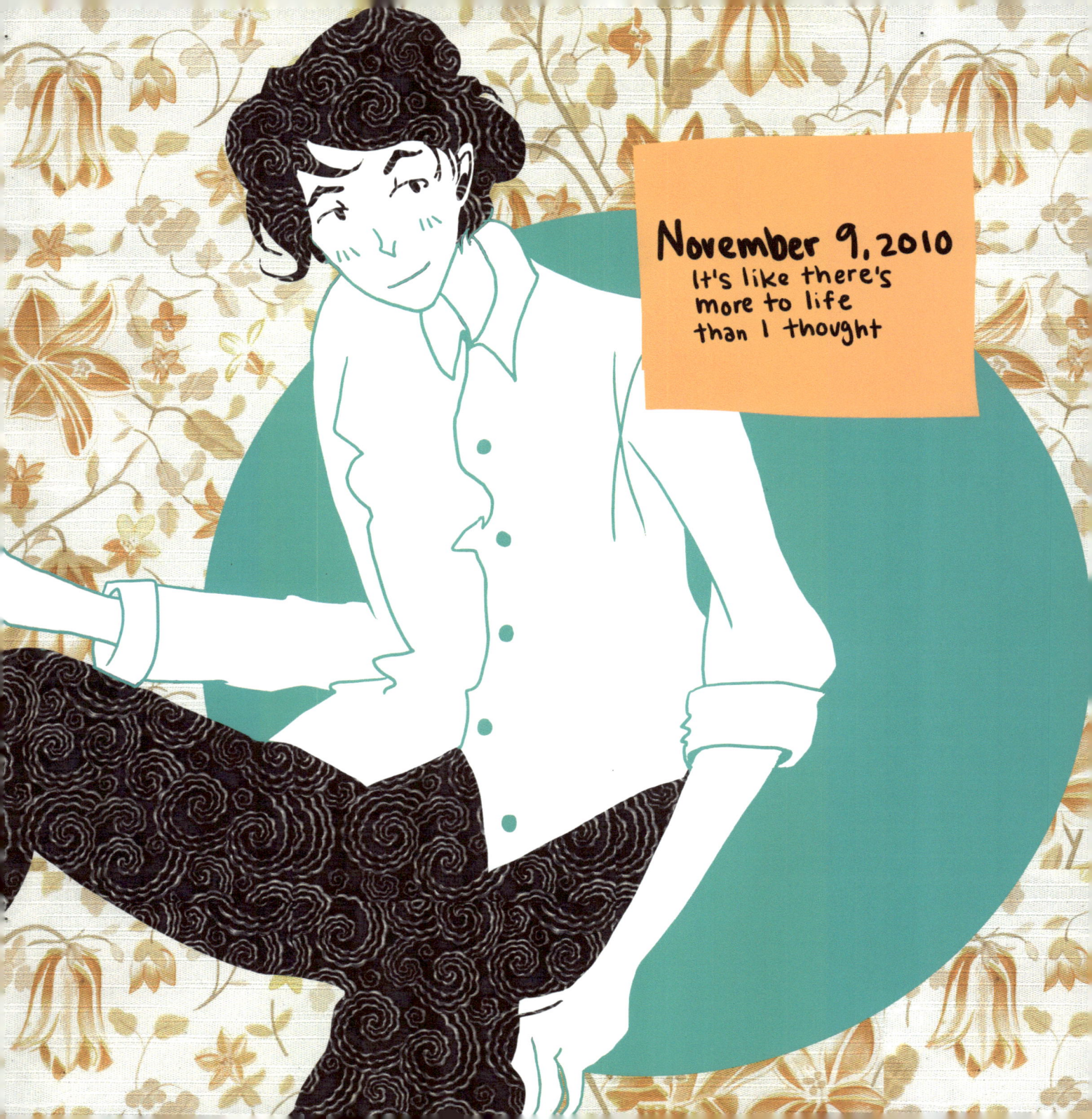

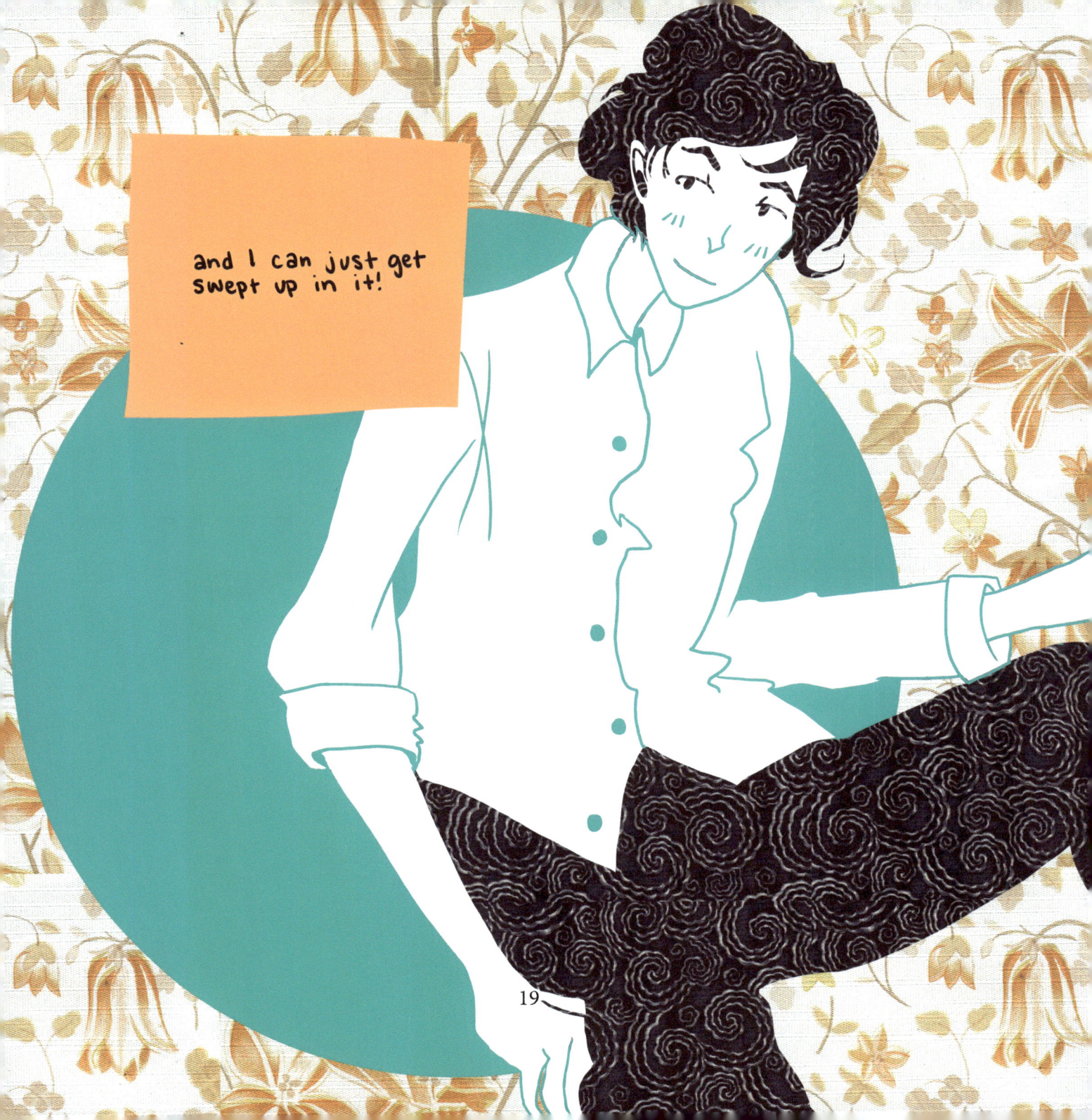

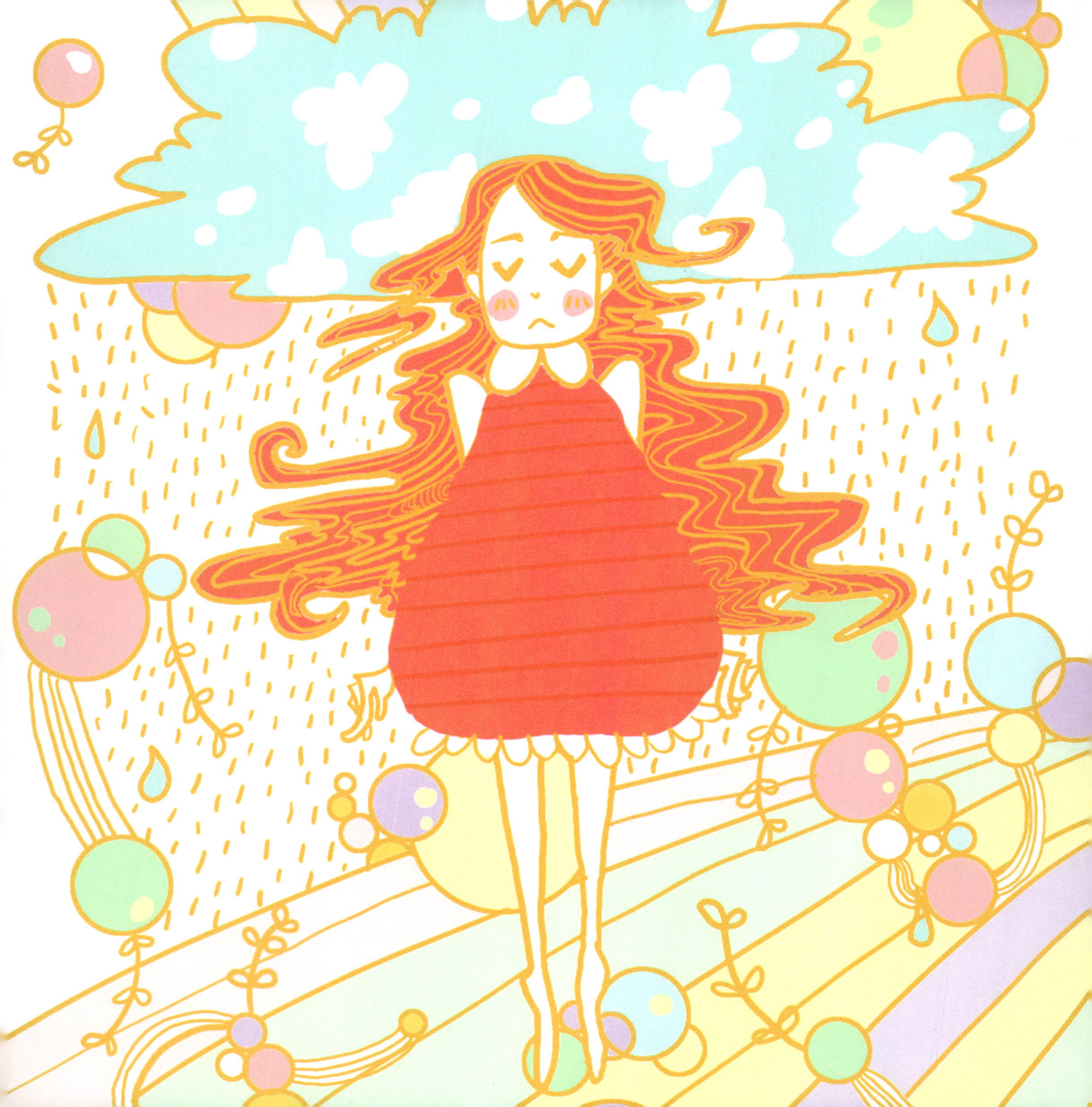

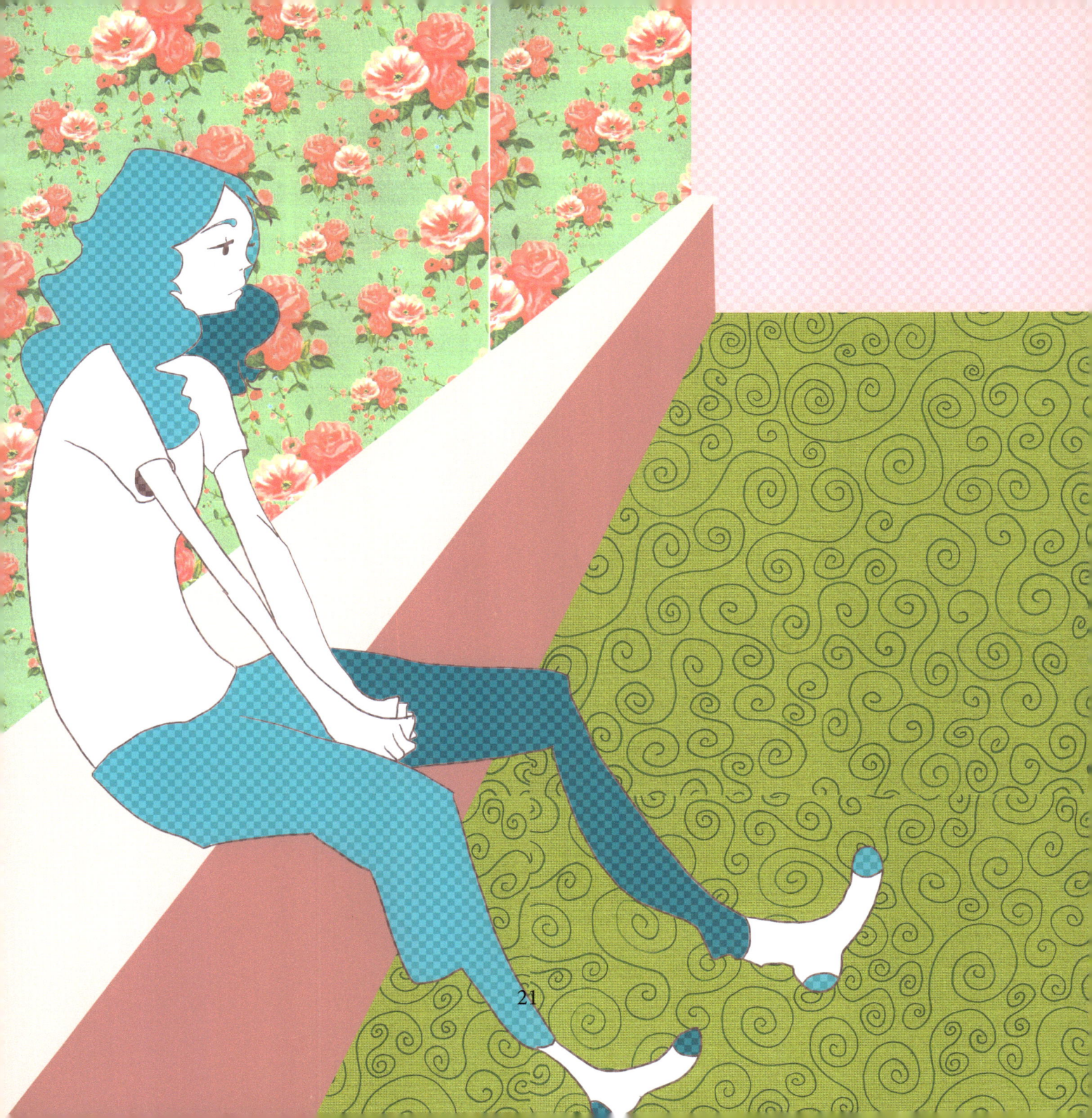

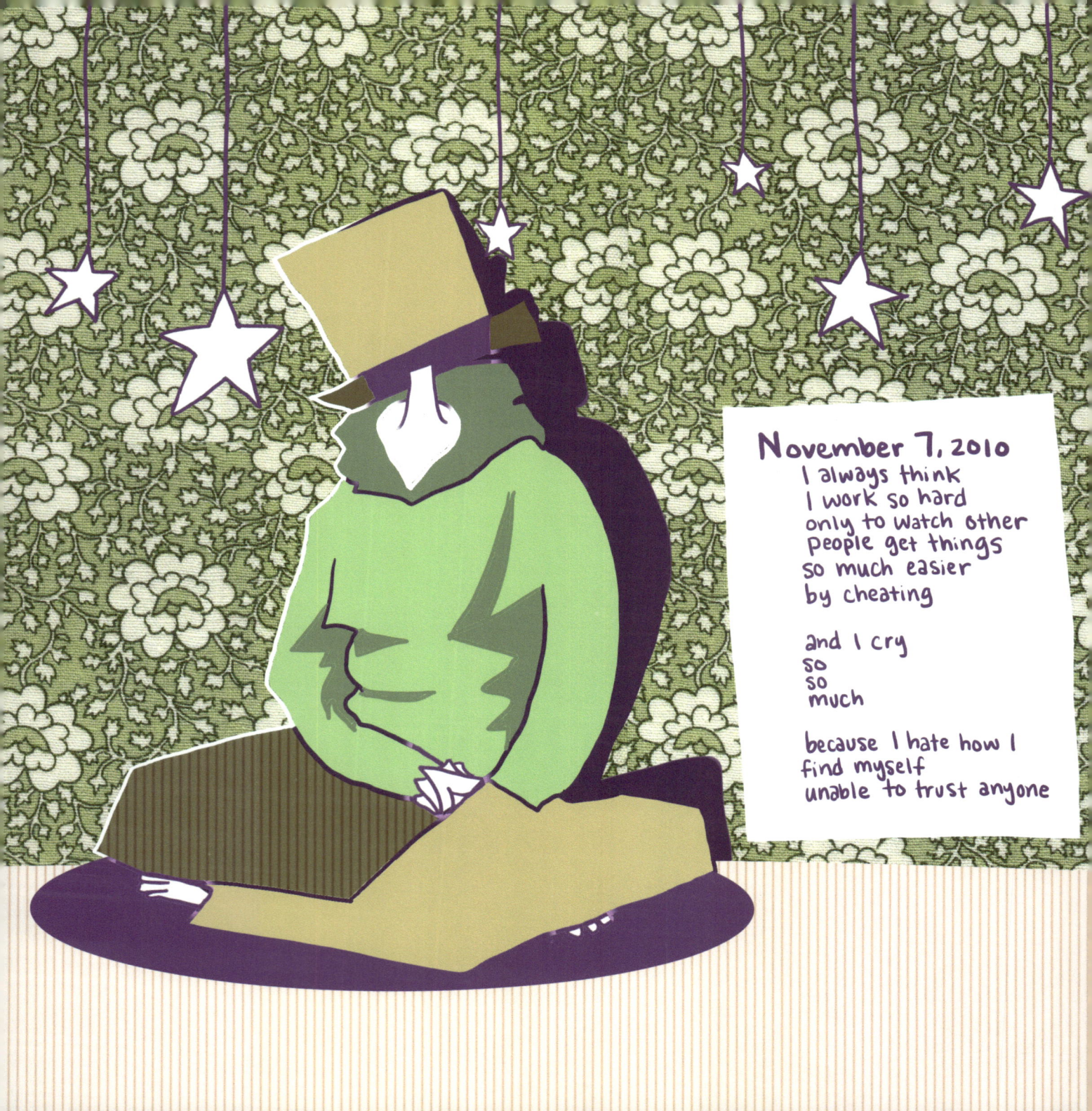

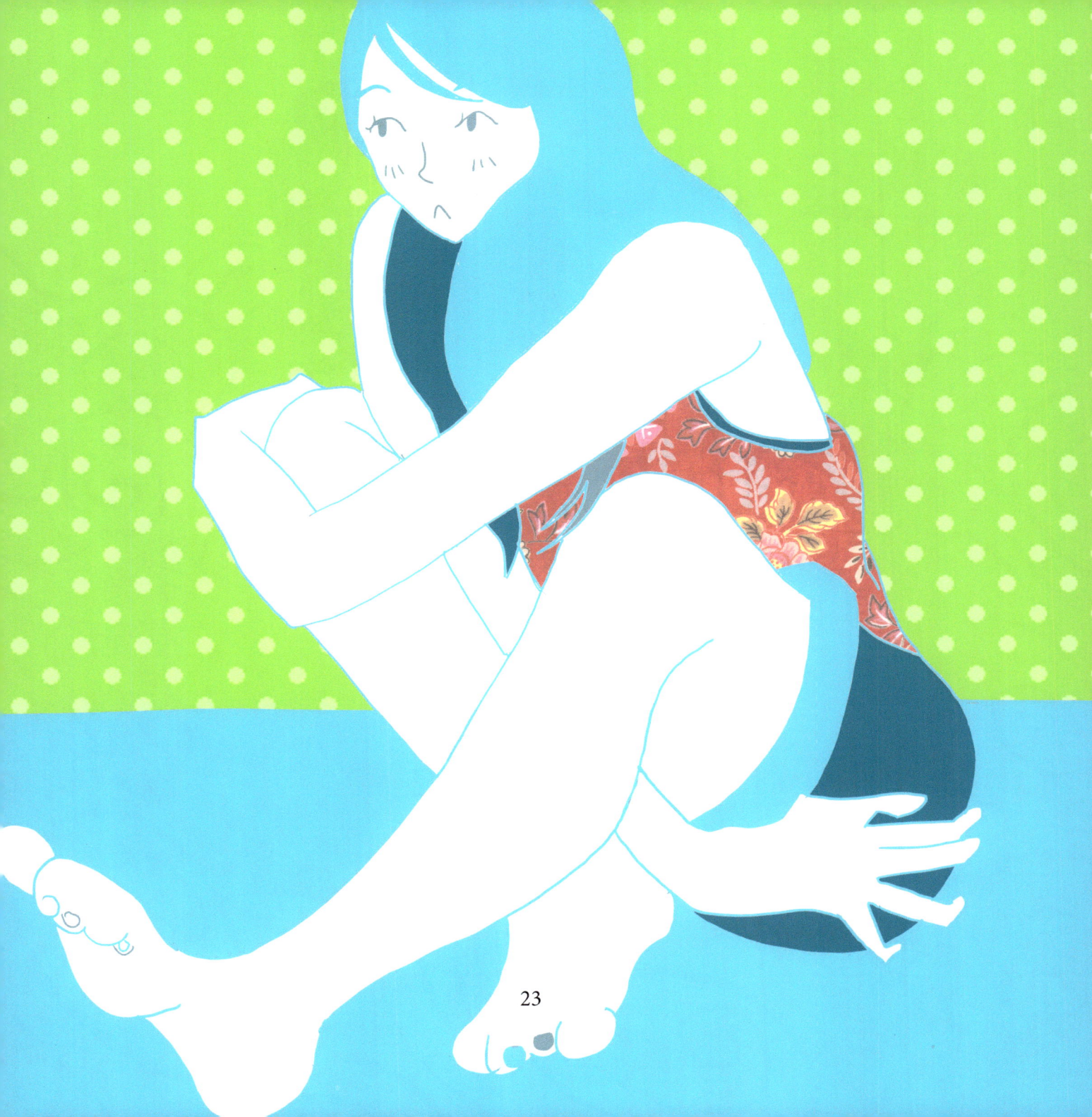

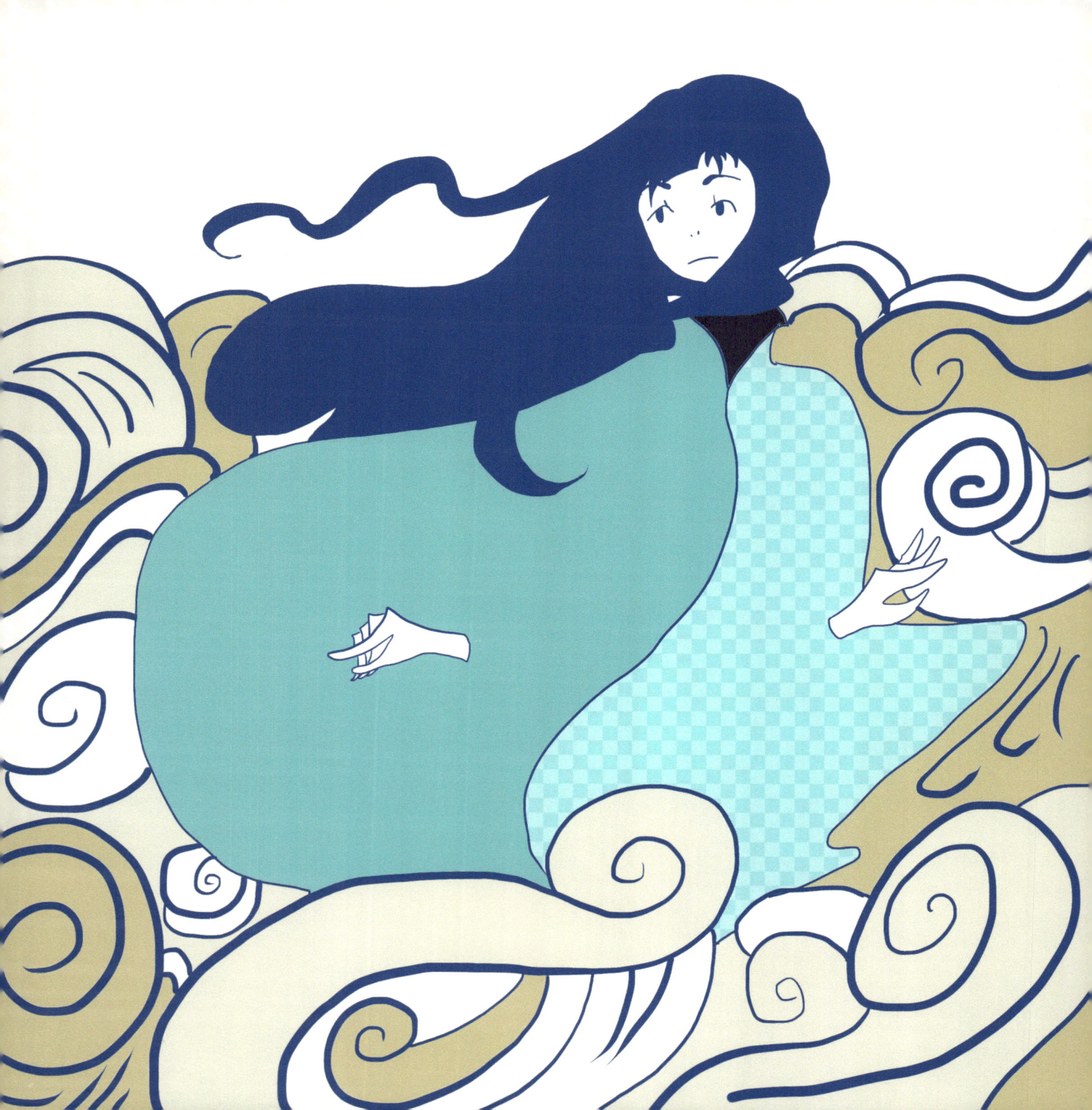

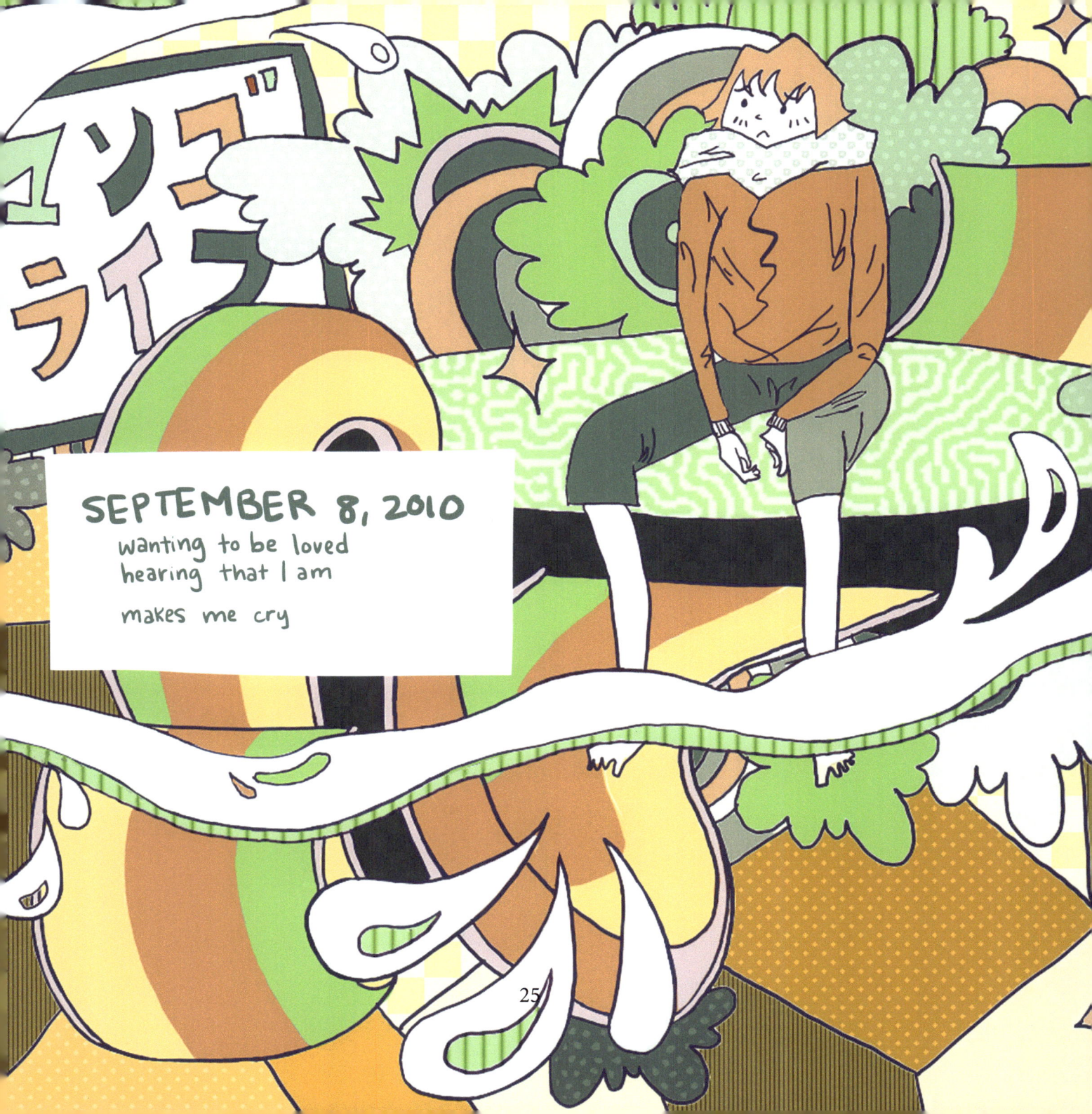

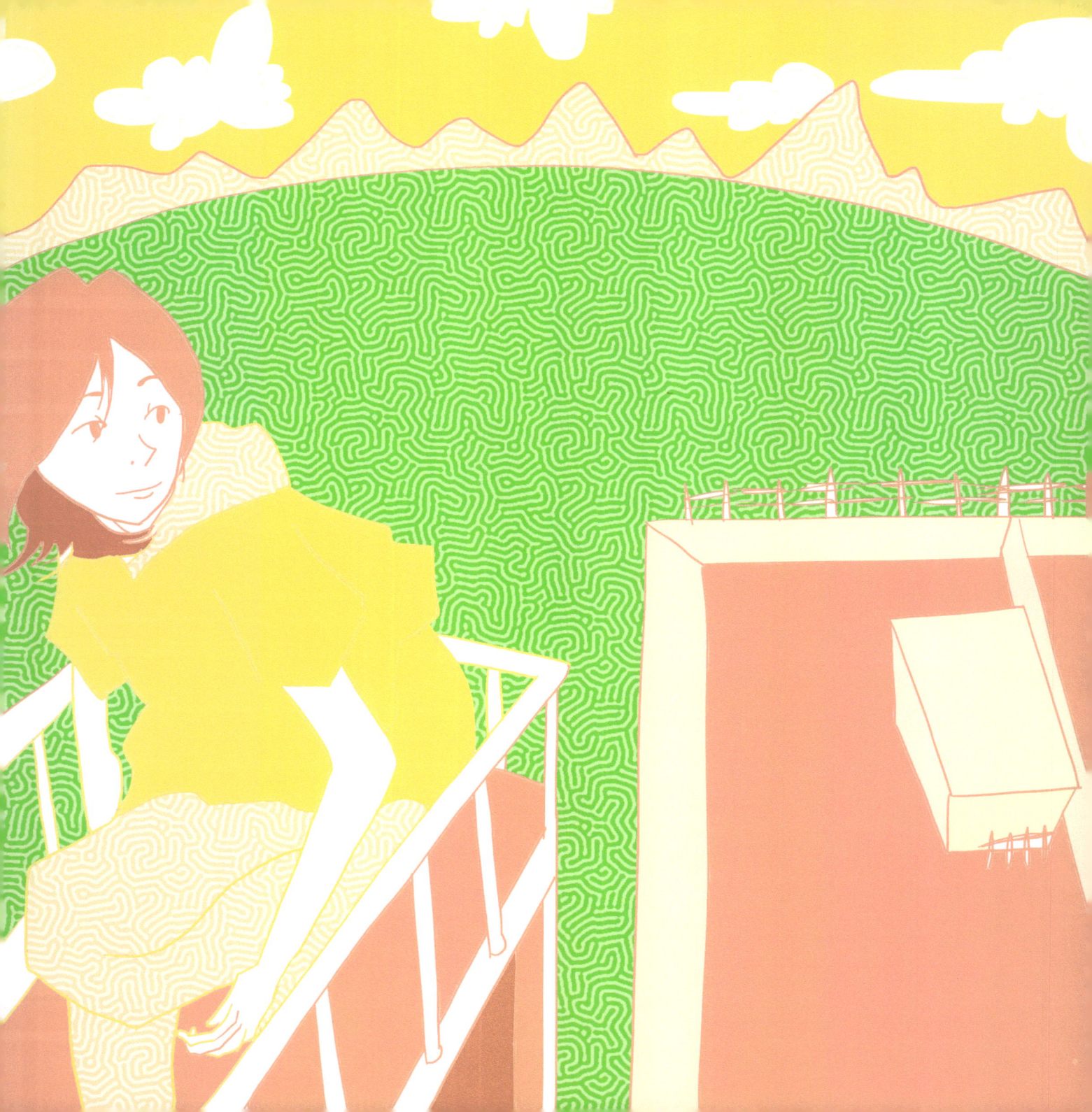

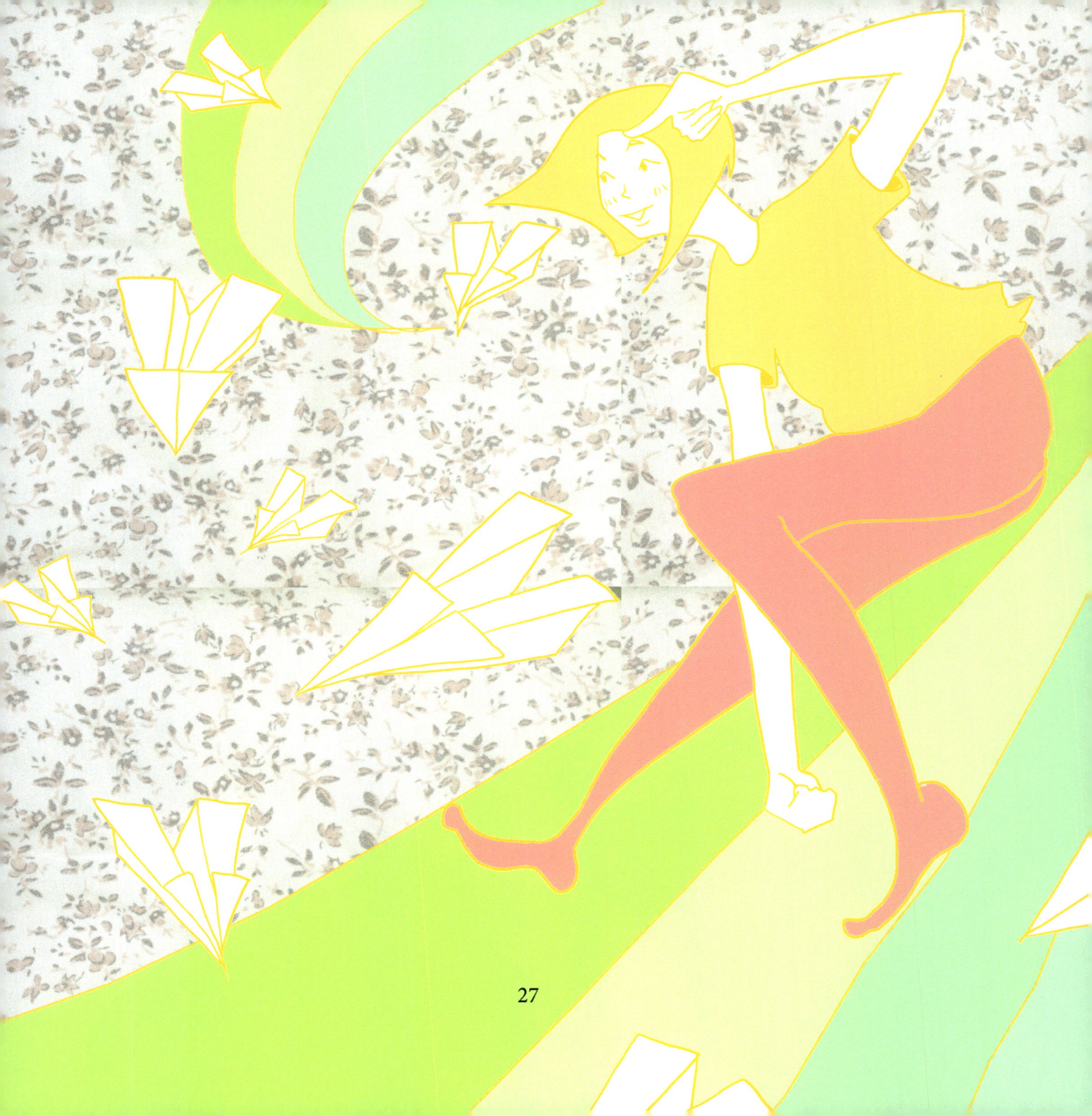

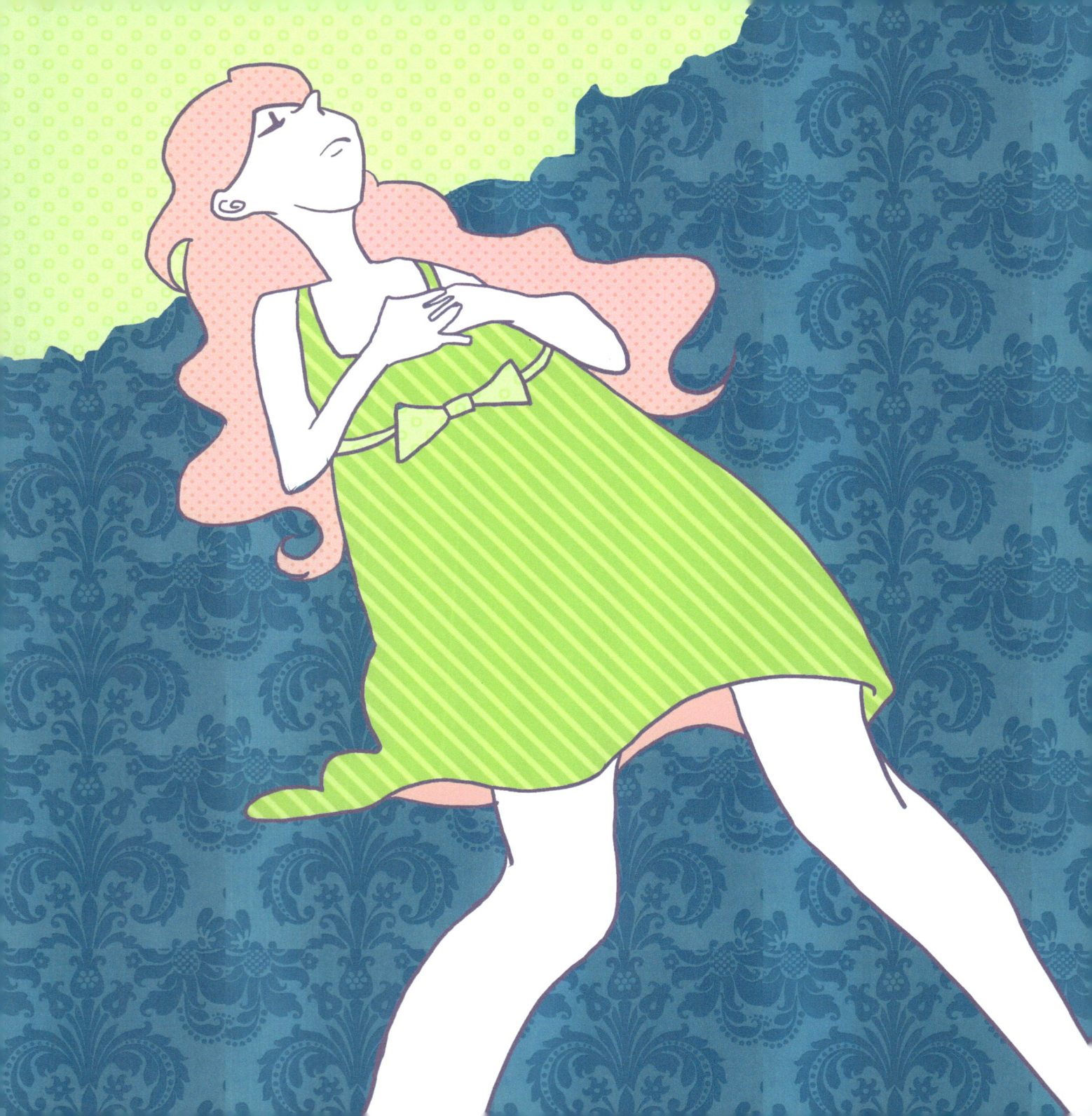

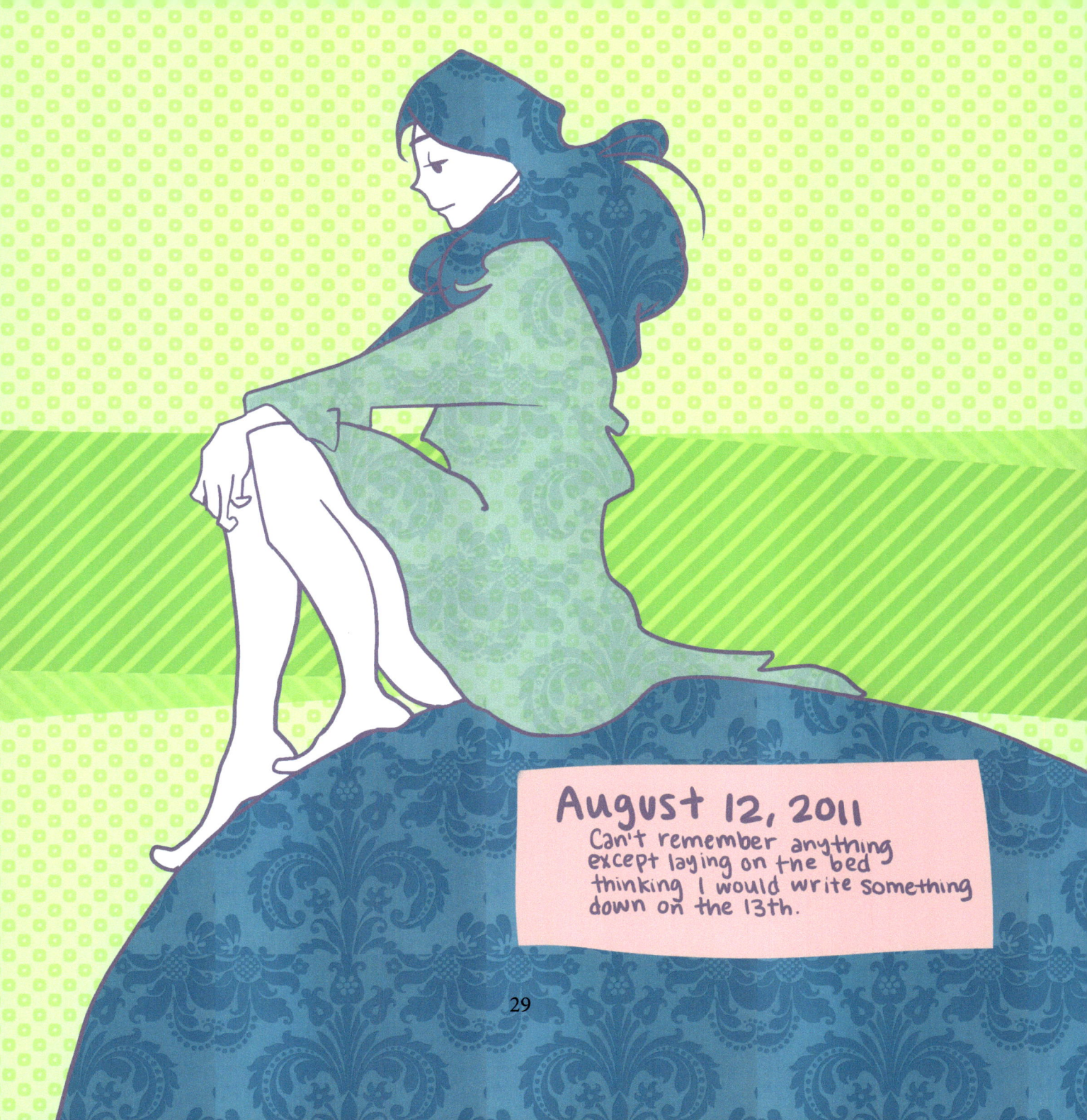

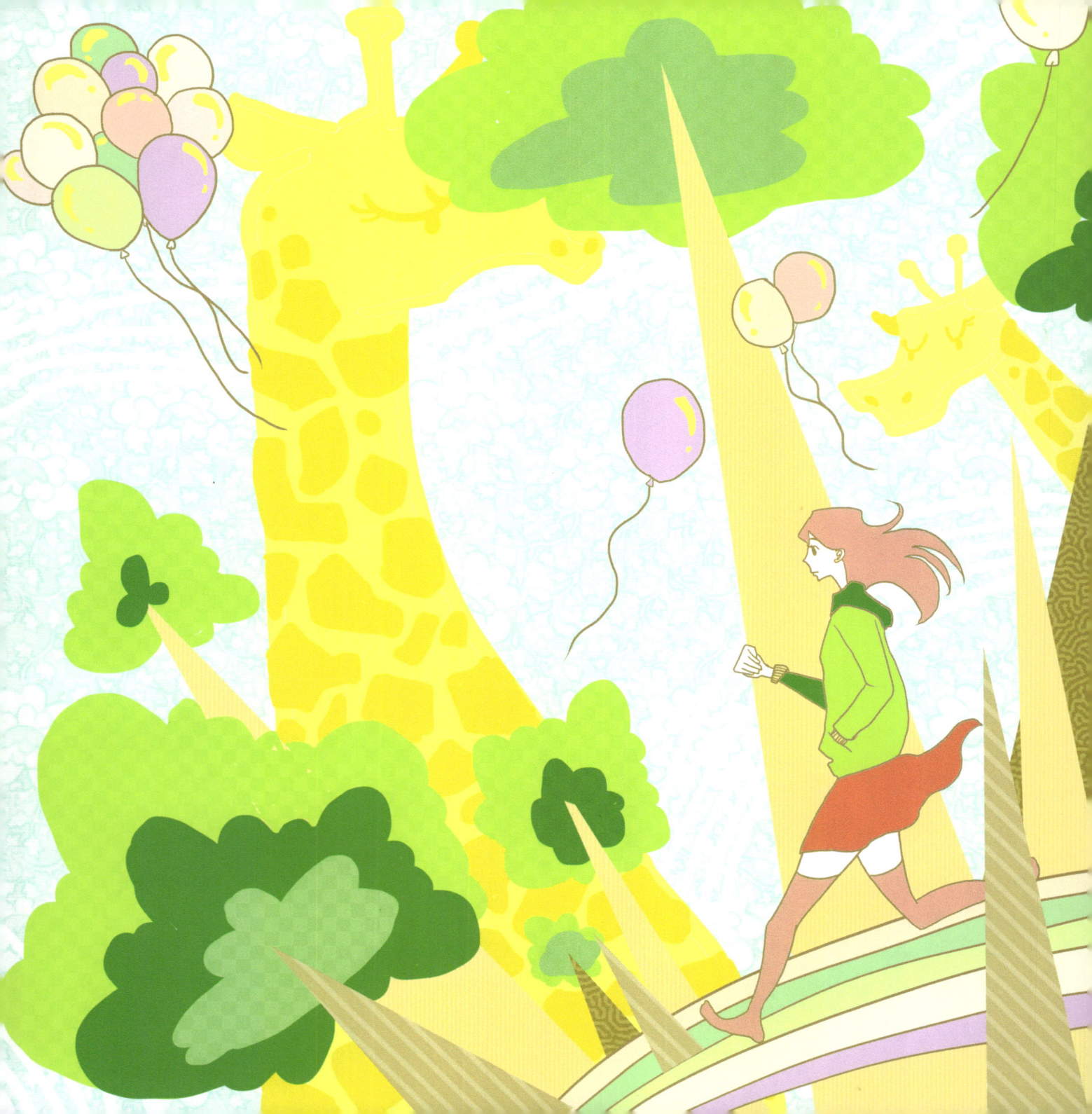

www.ingramcontent.com/pod-product-compliance
Lightning Source LLC
Chambersburg PA
CBHW041301180526
45172CB00003B/925